T0271611

REVISED EDITION

STICKERBOMB

LAURENCE KING

First published in Great Britain in 2008 by Laurence King Publishing Ltd
This edition published in 2024 by Laurence King, an imprint of
The Orion Publishing Group Ltd, Carmelite House,
50 Victoria Embankment, London EC4Y 0DZ

An Hachette UK Company

10 9 8 7 6 5 4 3 2 1

A CIP catalogue record for this book is available from the British Library.

ISBN: 978-1-39962-067-3

Research and edit by Suridh Hassan and Ryo Sanada of Soi Books
Designed and typeset by Soi Books
Title font: JF Rock © Jester Font Studio
Main font : Basic Sans © Latinotype

www.stickerbombworld.com
www.soibooks.com

Origination by f1 Colour
Printed in China by Leo Paper Products

www.laurenceking.com
www.orionbooks.co.uk

STICKERBOMB

★ SOI BOOKS ★

Laurence King

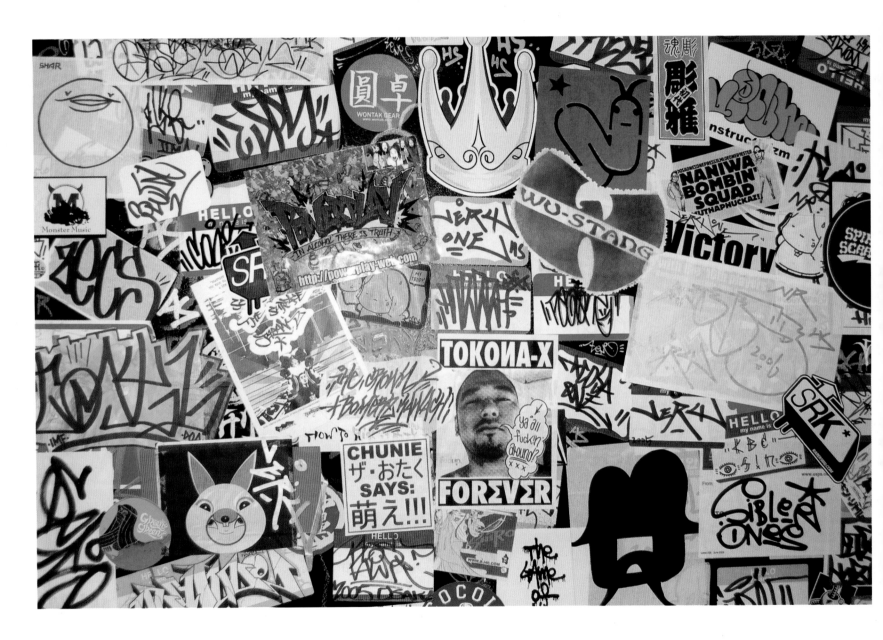

Back in 2008, we laid down the initial version of these thoughts. Since then, our journey as creators has taken intriguing turns. As the minds behind *Stickerbomb*, we've expanded from authors to publishers through Soi Books. Life has woven intricate threads – from parenthood's embrace to the passing of old chapters and the opening of new ones. We've watched street art, graffiti and sticker art shift and blossom.

But what's left to say about stickers? They remain a timeless delight, always inviting. Think Toaster stickers on the London Underground, BNE stickers on Tokyo's lamp-posts, Rarekind stickers in Amsterdam and D*Face stickers by Heathrow airport's bins.

Stickers transcend generations: kids trade them at school, teenagers slap them on skateboards, TVs and music systems. More than decor, stickers give artists a platform for self-expression and promotion. A sticker acts as a portable portfolio, staking a claim on street lamps, train cars and store counters. In an era of corporate saturation, stickers endure as a cost-effective way to assert individuality and leave a personal mark.

Authorities wrestle with stickers like they do graffiti, street art and stencils. Yet stickers pose a unique challenge – easily applied and hard to remove. Taking off an unwanted sticker can be a frustrating task, reflecting the human urge to leave imprints in various spaces, sustaining their omnipresence.

Since setting out, we've had the privilege of connecting with exceptional artists. Emails flooded in from around the globe, unveiling a diverse range of contributors – fine artists, graffiti virtuosos, animators, illustrators, even musicians. What unites them is their identity as artists, showcased within these pages, displaying elevated craftsmanship through the sticker medium.

This book – a patchwork of stickers – creates bridges between people and these remarkable artists. Stickers serve as our canvas, revealing the finest work of today's artistic vanguards. These pages stand as a testament to the boundless prospects of sticker art, a window into the brilliance these minds have harnessed within this versatile medium.

Now it's your call: do you hold onto these treasures within these pages, or do you release them, allowing them to journey and express themselves anew?

Shaz & Ryo, Soi Books 2024

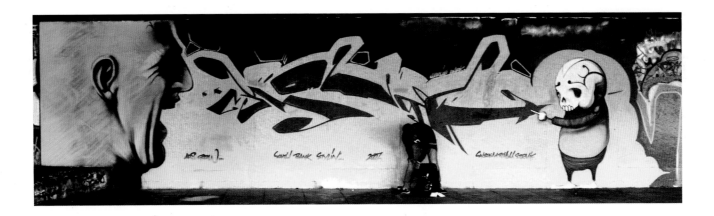

I've been making stickers since I started painting graffiti, over 23 years ago.

I have drawn my own on blanks and, in more recent years, designed them and had them professionally printed, but they still serve a unified purpose, which is to get my name up: a historic ethos I find very hard to let go of. As creative as my field of work can be, and despite the many places I've been and the journeys it has taken me on, one key line of thought within everything I do is the constant striving to keep my head above my peers. This is the ethos of any true graffiti writer.

I remember loving stickers as a kid. I was often given stickers by my dentist, my parents and my aunt and I would covet them and keep them all in a big folder, unstuck I hasten to add.... Now my four-year-old daughter also loves stickers, but unlike me she sticks them everywhere she can, on people, doors, radiators and her toys. I imagine as she gets older, maybe she will start to collect and keep them safe, perhaps in a big scrapbook or maybe in a folder like I did, but the fact that I have experienced this infatuation with the humble sticker firsthand within two completely different generations, tells me that there is a longevity to stickers. They can promote, decorate, temporarily mend things, say something or say nothing. They can be a warning, direction, praise of good behaviour or achievement, a means of identity, a label or even a postage stamp.

Stickers are prevalent in our society in so many ways. When you enter into some countries, they stick a travel visa into your passport, put flight identification stickers onto your luggage, and, if you cut your finger, hopefully there is a plaster to hand somewhere.

Every sticker that is stuck onto a street sign, telephone box or train window automatically becomes a part of our environment – much like the spray-painted daubings that gently decay into the fibre of urban living. They may fade in the sun, or the inks might run with the rain, but it takes a human hand to completely remove them and most of the time they have the ability to go undetected, avoiding destruction.

R. Stanton Avery was the inventor of the self-adhesive sticker, as we know it today. I doubt that he could have foreseen it becoming an application of artwork or the street art phenomenon it has become. But it has. The humble sticker is now a part of everyday modern life.

Keep sticking …

Remi/Rough, UK

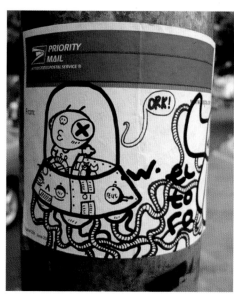
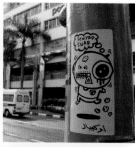

Hello, I'm Orkibal ... I remember when my friend asked me about what I'm doing with all those stickers I made ... I told him I'm just discovering how to spread my art ... he said ... I don't believe u can have success doing that ... I looked at his face and continued to finish my stuff ... I told him, 'yeah I don't give a fuck about you, I don't want to be there sitting in the future regretting not doing this and ending up being some stupid supervisor like you ... just working and talking like you are some superman ...'

And now, today, I have so many friends around the world ... all thanks to sticker propaganda I made for the last four years ... from stickers I can show people all my work ... my expressions ... most important is my art ... maybe normal people think this is like a childish thing, wasting time and money ... but for me this shit is like my own Alice-in-the-Wonderland-kind-of...I can't tell you guys about that feeling when you see your sticker on the street and people talk about it but just don't know that you are the guy who did it ... priceless ...

For me, stickers make a big impact for my life ...

LONG LIVE STICKERS and STREET ART

Orkibal, Kuala Lumpur, Malaysia

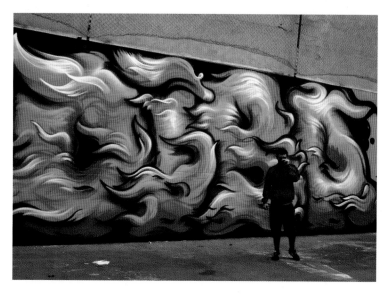

I hate branding using a computer. You made a design, you finish it, you print it out or display it somewhere and that's it, it is all done. It is a hundred times better branding by hand.

Pick a sticker. Don't think about the perfect place to stick it, there is no such thing. Just choose the one you like most and remove it from the book to bring it to life ... Warning: be gentle with the sticky side and avoid touching it with your fingertips. Now, enjoy the smell of the glue as it won't last for long. Choose a spot right now and stick it there! Stick it strongly, press the sticker as if glue had not been invented yet ... Now things will never be the same again ... Do not regret and do not dare to remove it. A sticker that has been removed is like an erased tattoo. Once it has been placed it remains in that spot forever.

Now you are ready ... start branding with your bare hands.

Brand for fun and stop nonsense marketing.

Enjoy bro!

Dibo, Spain

The tradition of a person putting a sticker on public property has been around for ages. People will put their name, company, service, tag on sticky-back paper and put it up to gain recognition, promotion, fame and notoriety. It's kinda the same as cheap advertising, and for a graffiti writer it can achieve something resembling a pen or sprayed tag, but with much less risk than using the real thing. In terms of time, placing a tag with conventional graffiti, you have to be in position for at least five to ten seconds, probably more depending on how elaborate your tag is; with a sticker, you can place it while walking, with sleight of hand movement, unnoticeable to pretty much everyone. As a young graffiti artist, I used to consider stickers a poor way of getting up: not much risk involved and most of the ones you saw about were illustrated characters, not really tags. It wasn't graf. The more I got into graffiti, the more I got into art – not the old classic stuff but art produced by new artists. I started looking at different ways of getting up. Then Shepard Fairey came into my view with his iconic Andre the Giant stickers. This street art quickly became infamous. I didn't know where it had come from, who it was, nothing. Then I found out you could send off for or download his stickers. He got up. He had heads worldwide placing that sticker. Then came Solo1. He started placing Royal Mail 'signed for' stickers on everything all over London. At times you would see five or more all over one street sign. This is when I realised it was a good way of getting up. He started a massive trend, kinda broadened the media used by proper graf artists ... more and more heads started stickering. Influenced by Solo, Roser and me got on the stickers. We were racking up loads of 'signed for' ones and putting ten or so together, and with racked Tipp-Ex pens and black markers started to produce full-on pieces on them. We would place them everywhere. My favourite was the London tubes; sometimes they would not stay because of the dirt, but when they did, they looked cool. We got 'em up everywhere. Royal Mail clicked on after a couple of years. They realised what was going on – loads of their stickers going missing and not as many parcels being sent. They ended the fun and stopped the full sticker and made it paper. As time has gone on, I still don't give the top respect to sticker peeps, I don't consider it real graffiti, but I do admire the ones who get up proper with them. It's evolved into its own culture.

Dasone (RK), UK

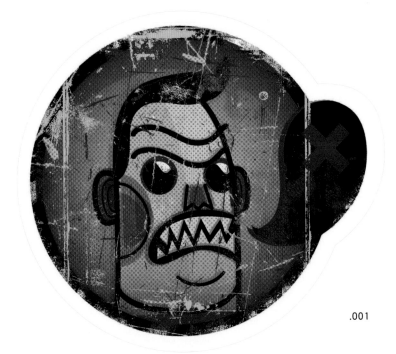

.001

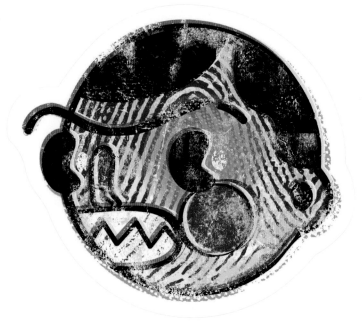

.002

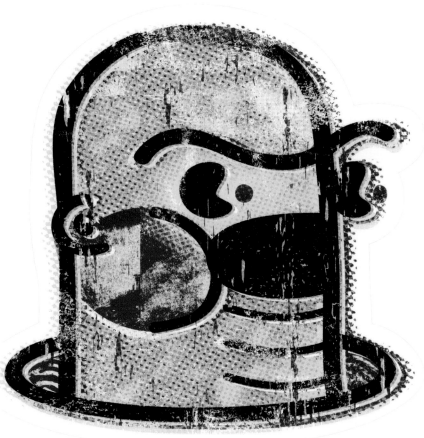

.003

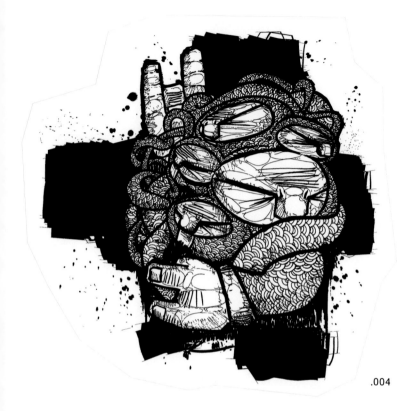

.004

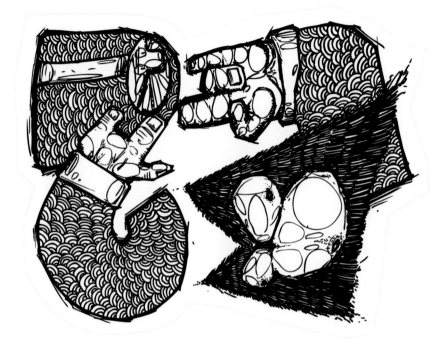

.007

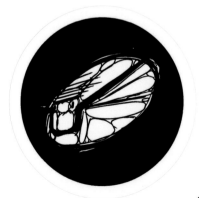

.005

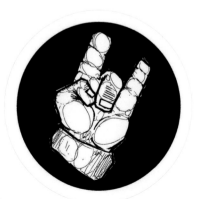

.006

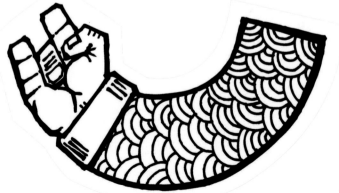

.008

THE SHAPE OF OUR NUGGET IS CHANGE IN ALL SENSE OF EPIC. WORD IT HARD LIKE THE FINAL LACE.

**~!!

.009

SEE!!

.010

THIS IS THE HEAVY SCRIPT WHAT WEIGHS A TONNAGE LIKE CHUCK'S CHIP. AND WHEN THEY ARE DOWN THE NIGGA WILL JOIN ME IN THE SIGH OF TREES.

.011

I AM THE PRANK OF BRISTOL'S FINAL MEMORY. THE BIGGA NIGGA WITH ME HAND ON THE TRIGGER POW EVERY!! THING.

.012

.013

.014

.015

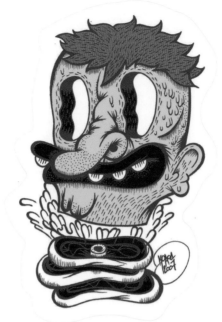

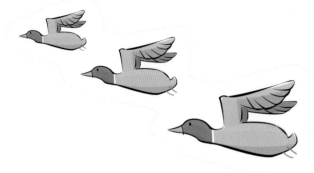

.016

.017

.018

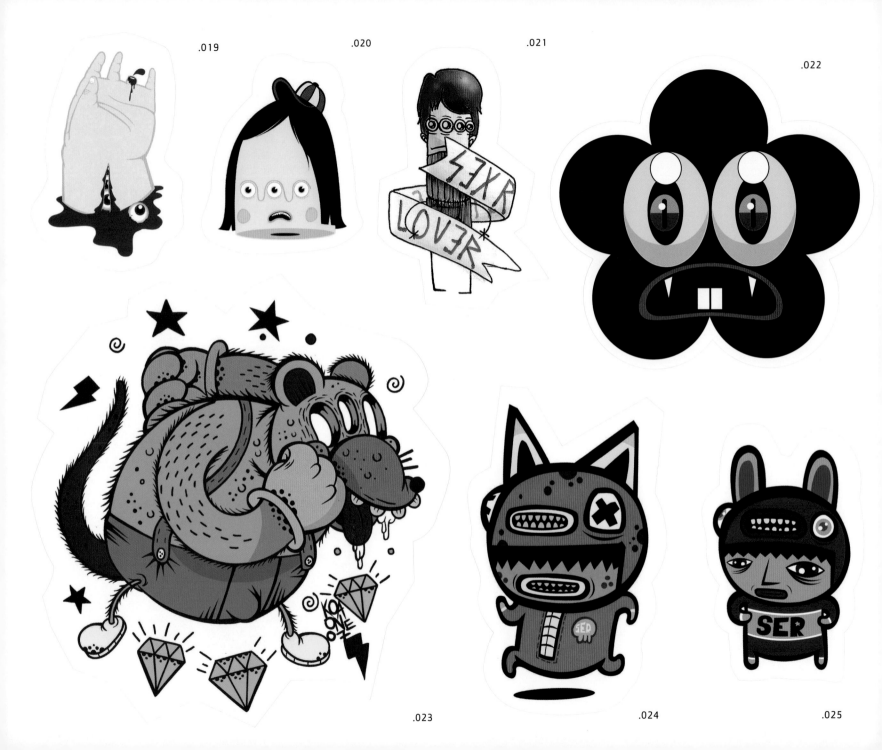

.019

.020

.021

.022

.023

.024

.025

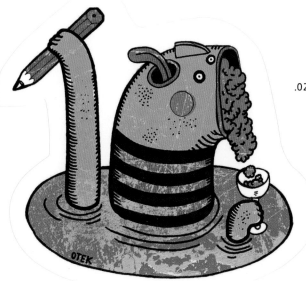

.026

.029

.030

.027

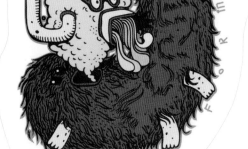

.028

.031

.032

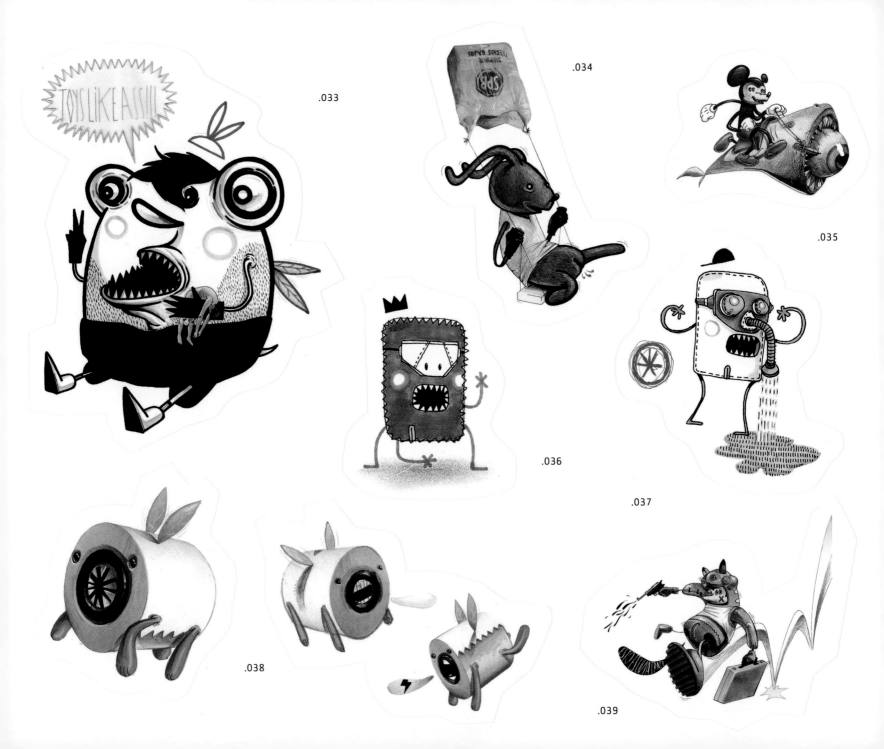

.033

.034

.035

.036

.037

.038

.039

.040

.041

.042

.043

.044

.045

.046

.047

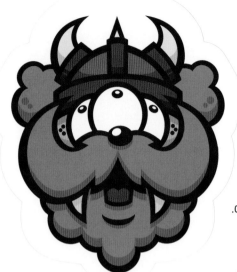

.048

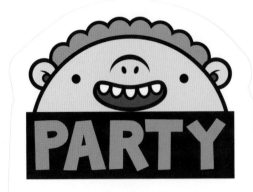

PARTY

.049

.050

.051

.052

.053

.054

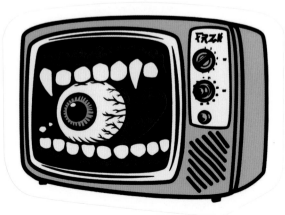

.055

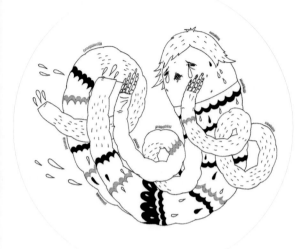

.056

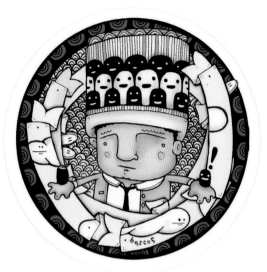

.057

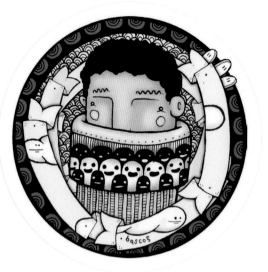

.058

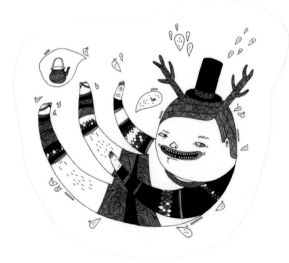

.059

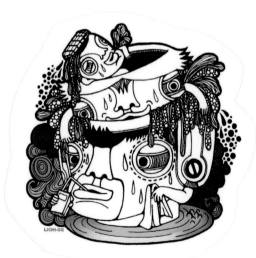

.060

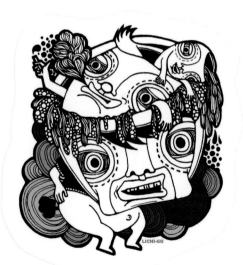

.061

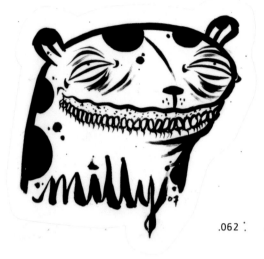

milly

.062

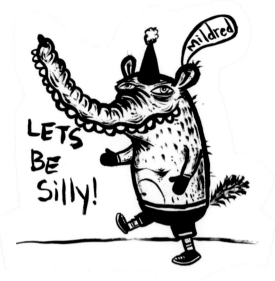

mildred

LETS
BE
Silly!

.063

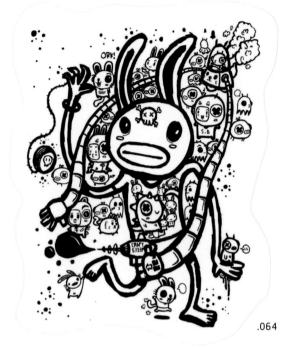

.064

07

.065

millilly 07

.066

.067

.068

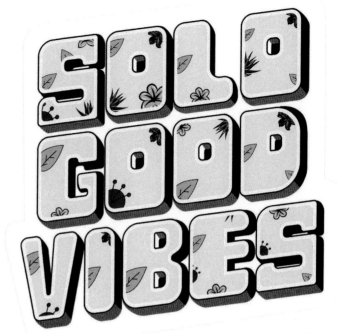

.069

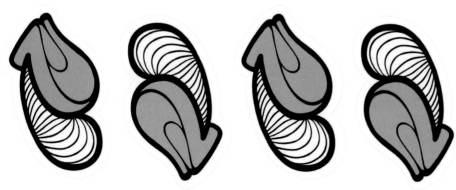

.070

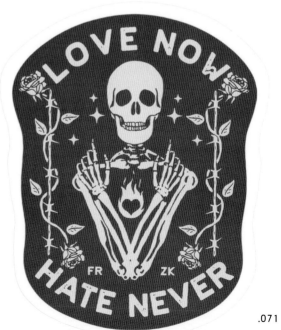

.071

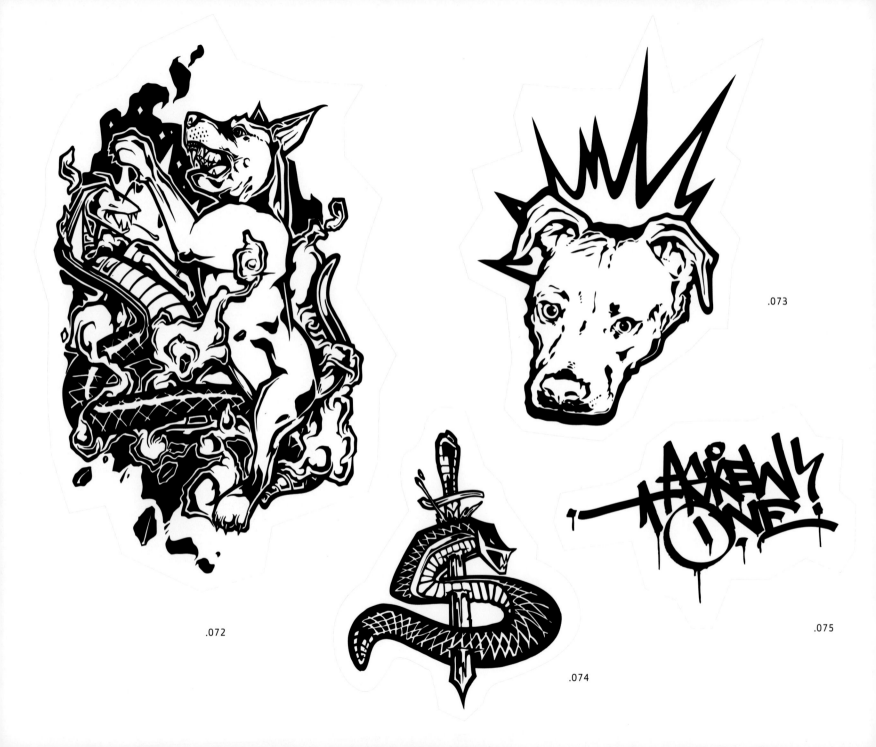

.073

.072

.074

.075

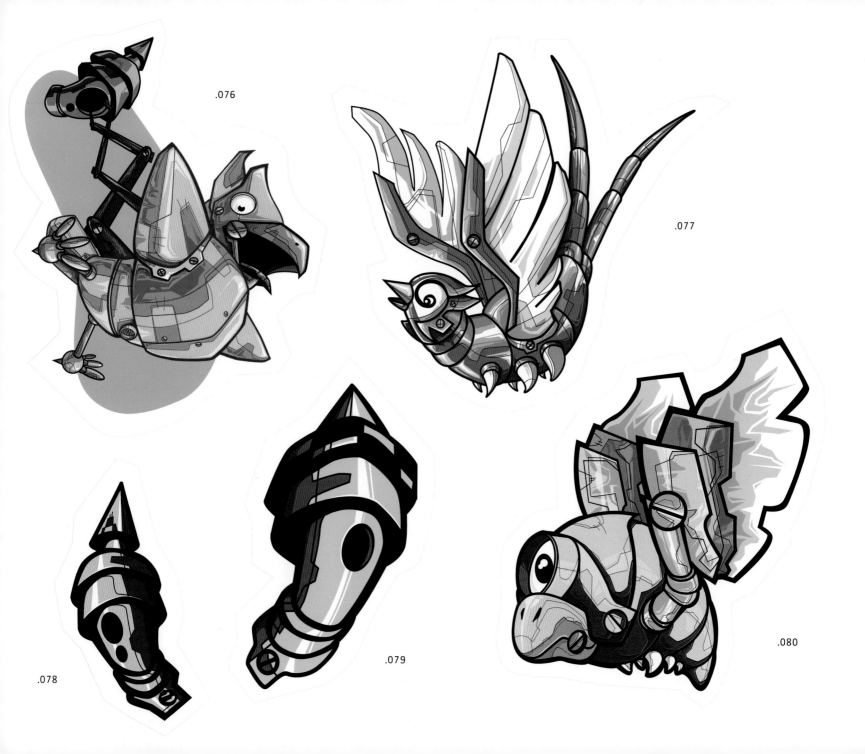

.076

.077

.078

.079

.080

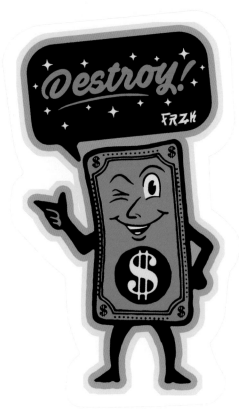

.081

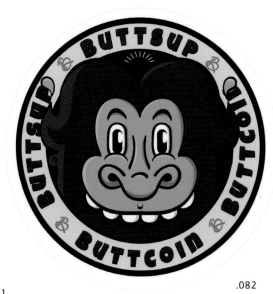

.082

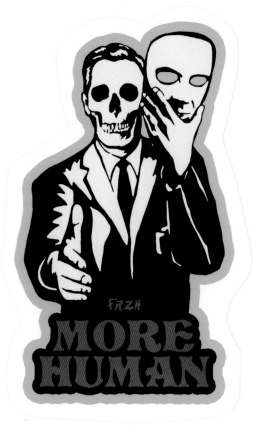

.083

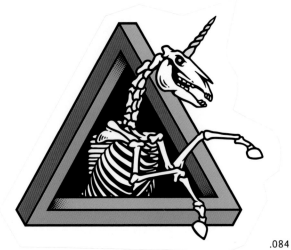

.084

.085

.086

.087

.088

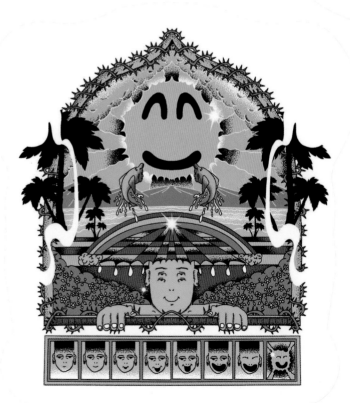

.089

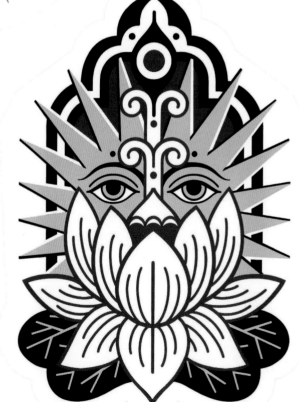

.090

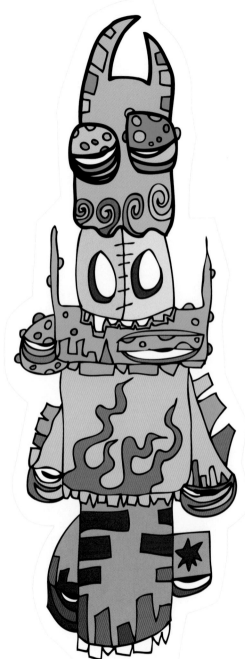

.091

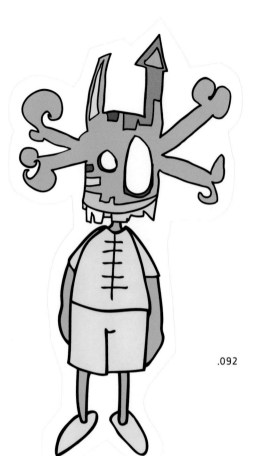

.092

.093

.094

.095

.096

.097

.098

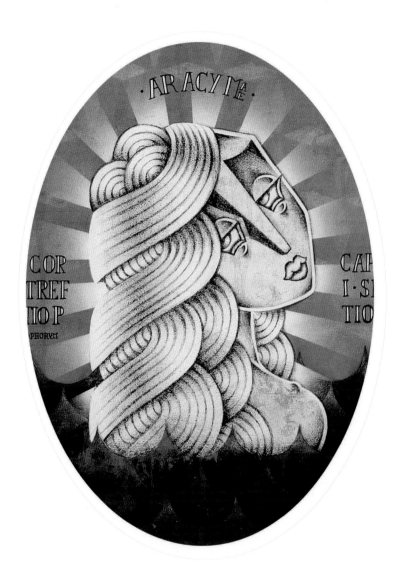

.99

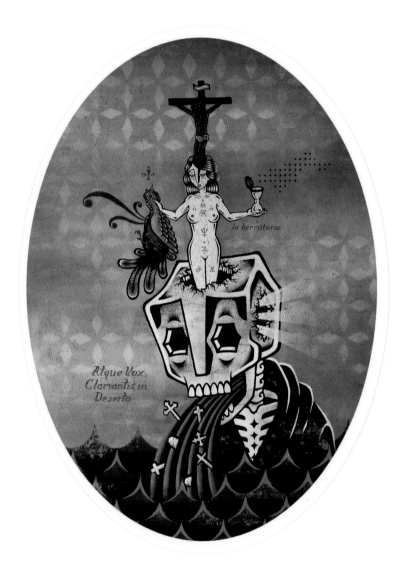

.100

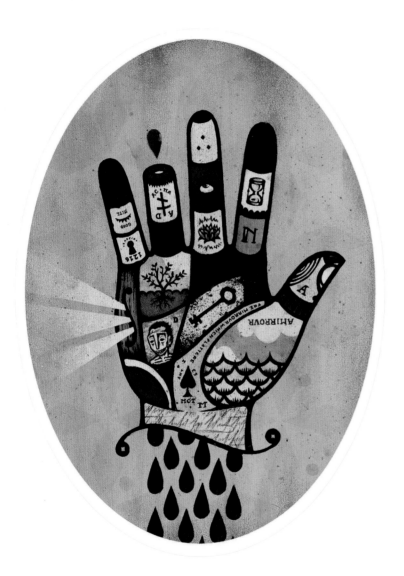

.101

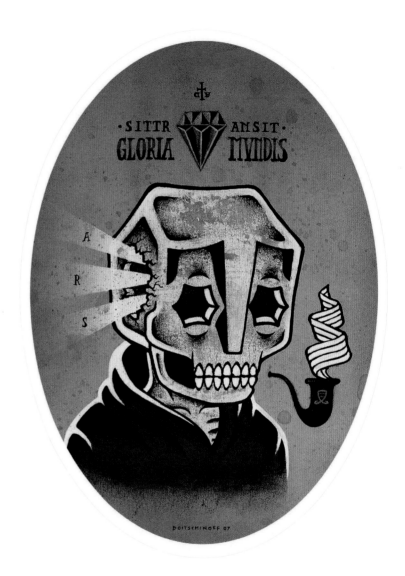

.102

.103

.104

.105

.106

.107

.108

.109

.110

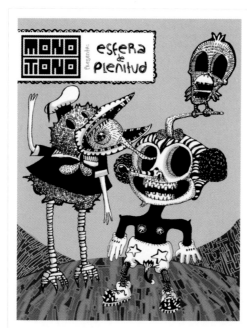

.111

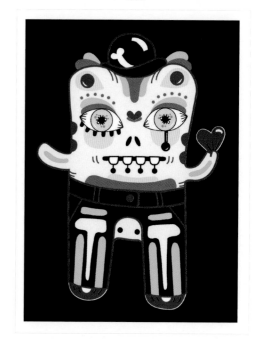

.112

.113

.114

.115

.116

.117

.118

.119

.120

.121

.122

.123

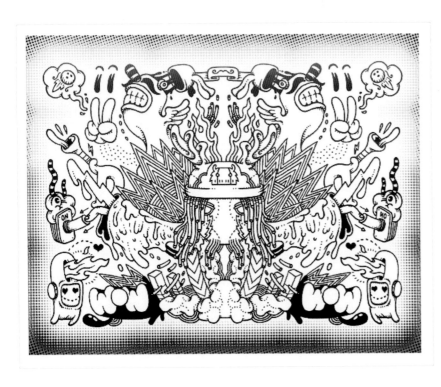

.124

.125

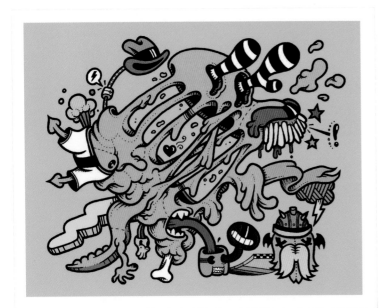

.126

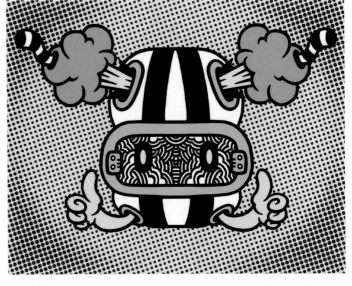

.127

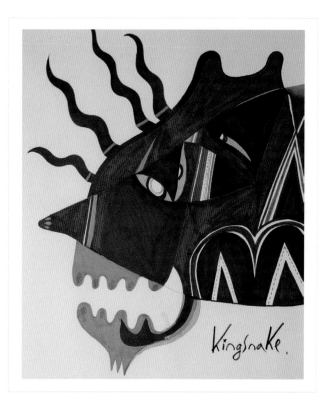

Kingsnake.

.128

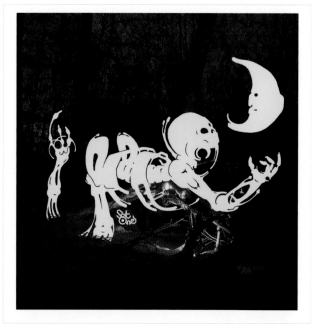

.129

.130

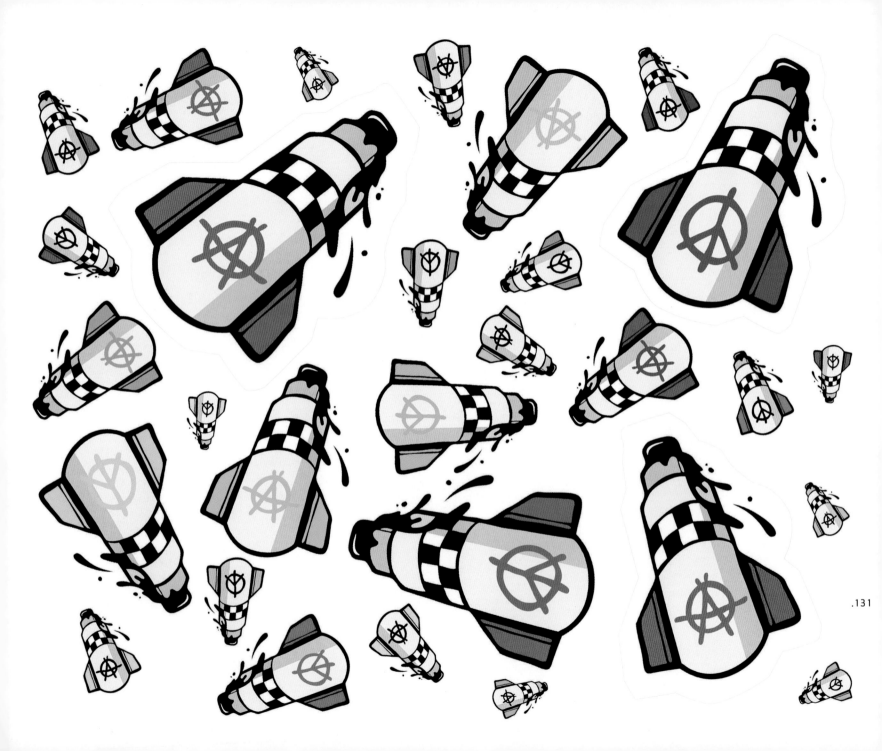

.131

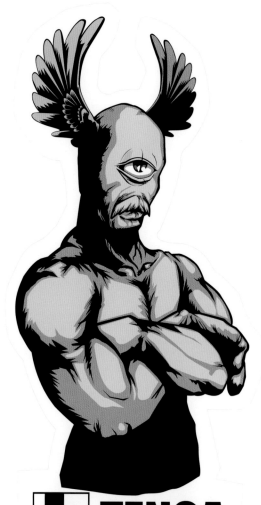

TENGA

3AM×NANASHI×SML

.132

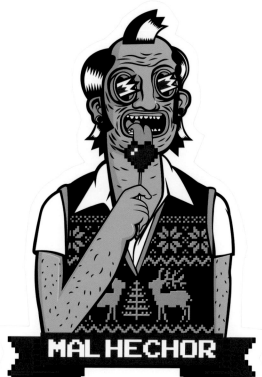

MAL HECHOR

.133

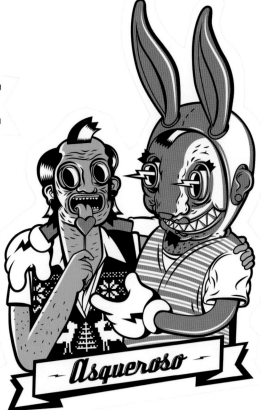

Asqueroso

.134

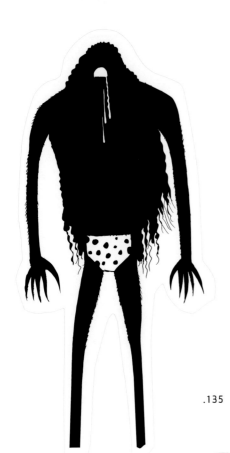

.135

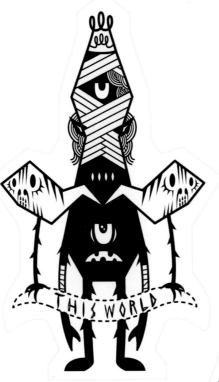

.136

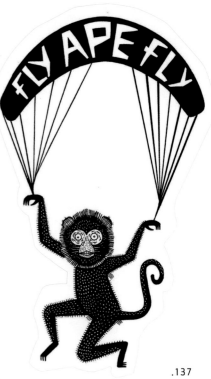

.137

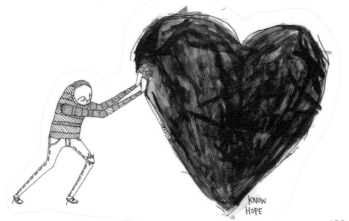

.138

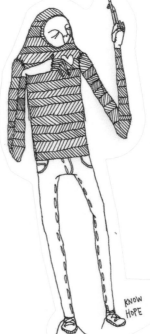

.139

.140

.141

.142

.143

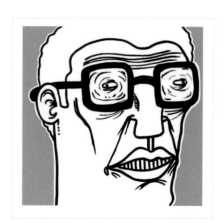

.144

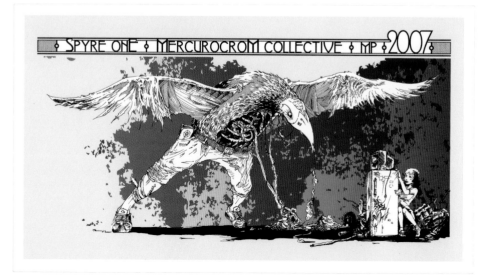

.145

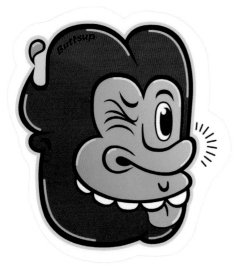

.146

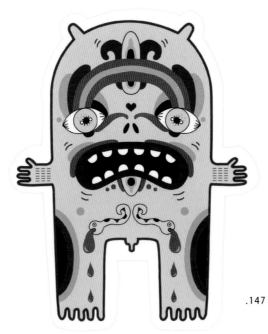

.147

.148

.149

.150

.151

.152

.153

.154

.155

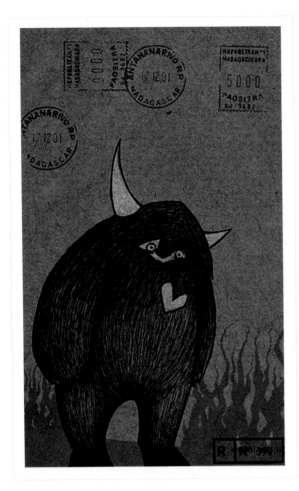

.156

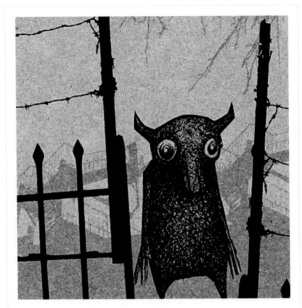

.157

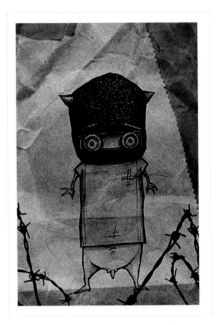

.158

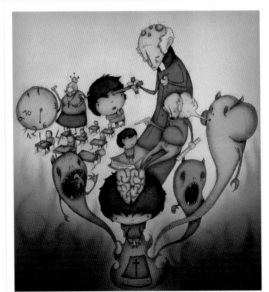

.159

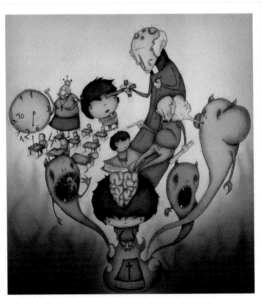

.160

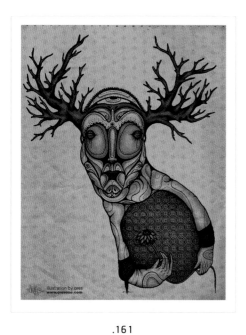

.161

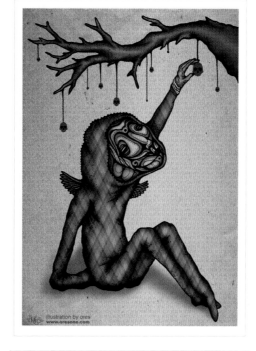

.162

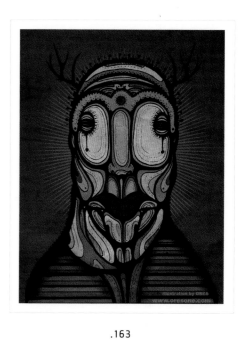

.163

.164

.165

.166

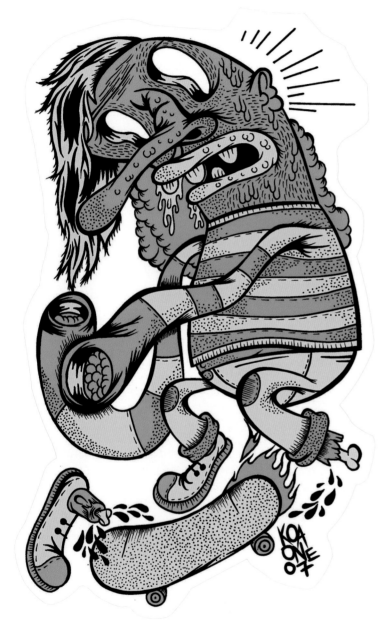

.167

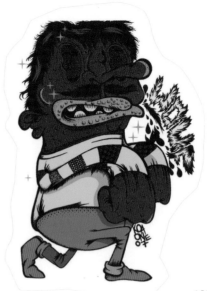

.168

.169

.170

.171

.172

.173

.174

.175

.176

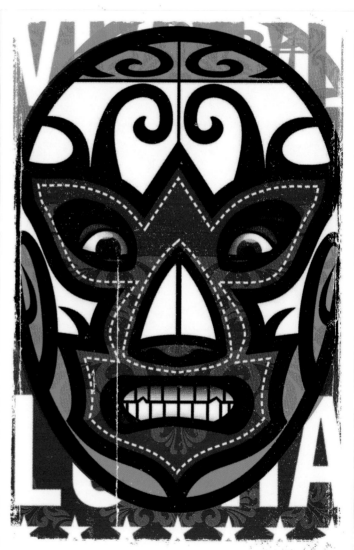

.177

PelandoCable

.178

VER para CREER

.180

MEH!

.179

VER para CREER

.181

Taller huitongo

.182

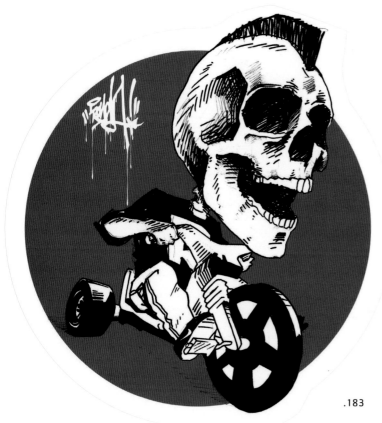

.183

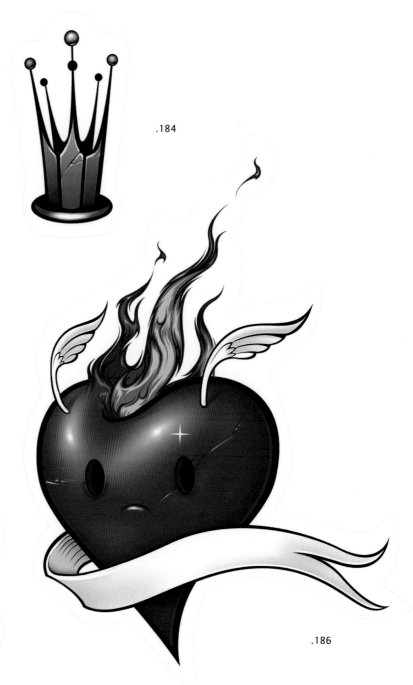

.184

.186

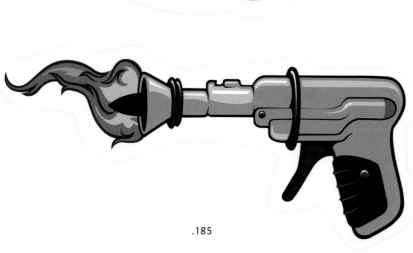

.185

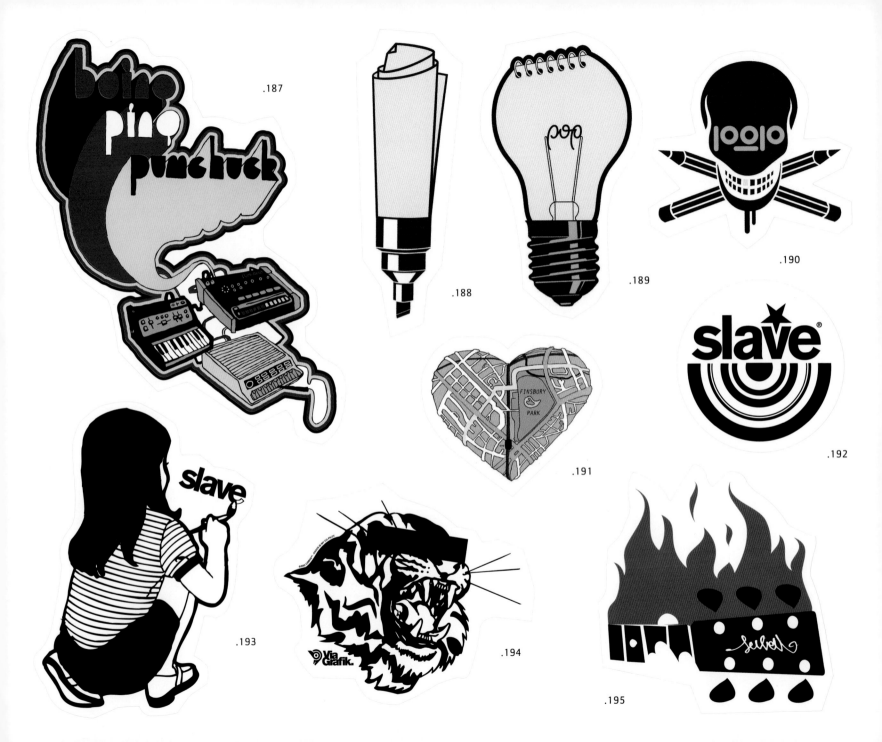

.187

.188

.189

.190

.191

.192

.193

.194

.195

.196

.197

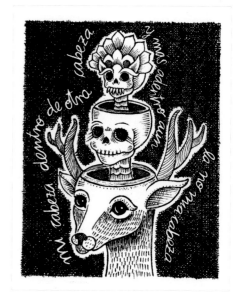

.198

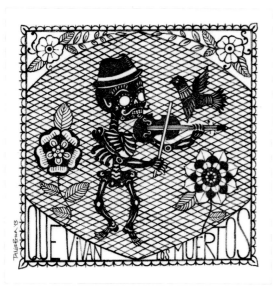

.199

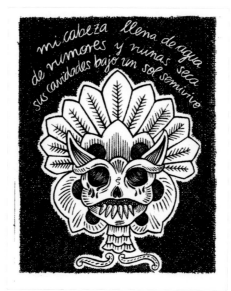

.200

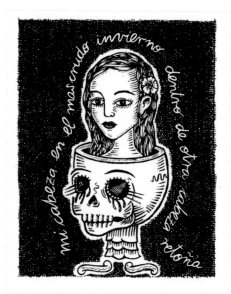

.201

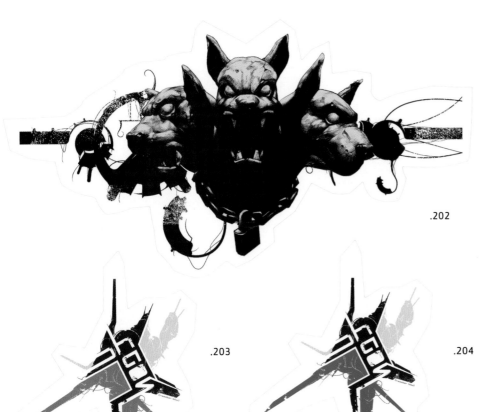

.202

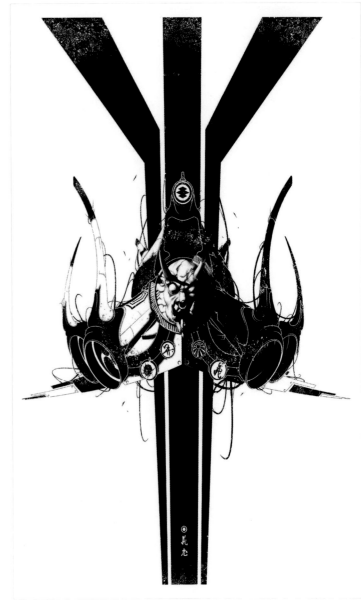

.203

.204

.205

.206

.207

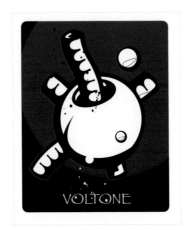

VOLTONE

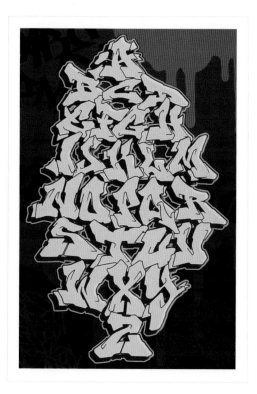

.208

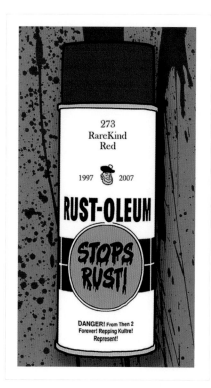

.209

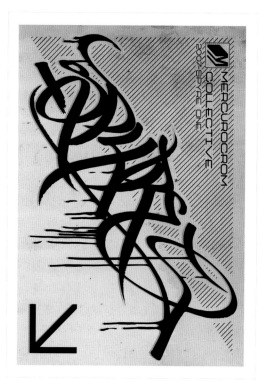

.210

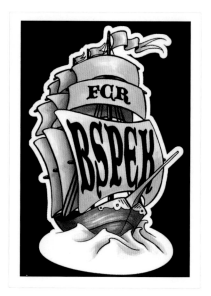

.211

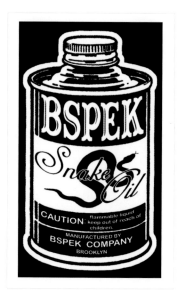

.212

.213

.214

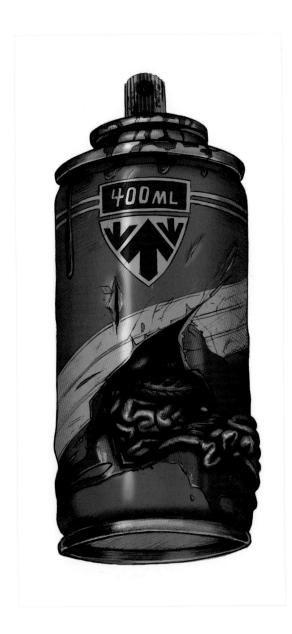

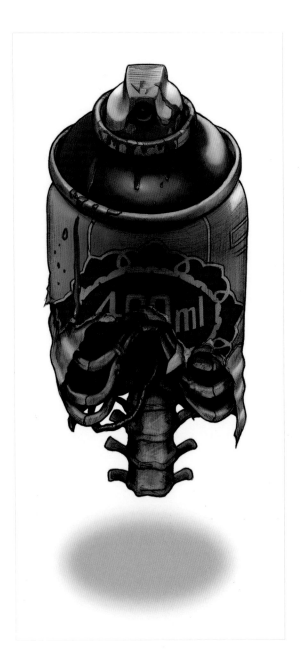

.215

.216

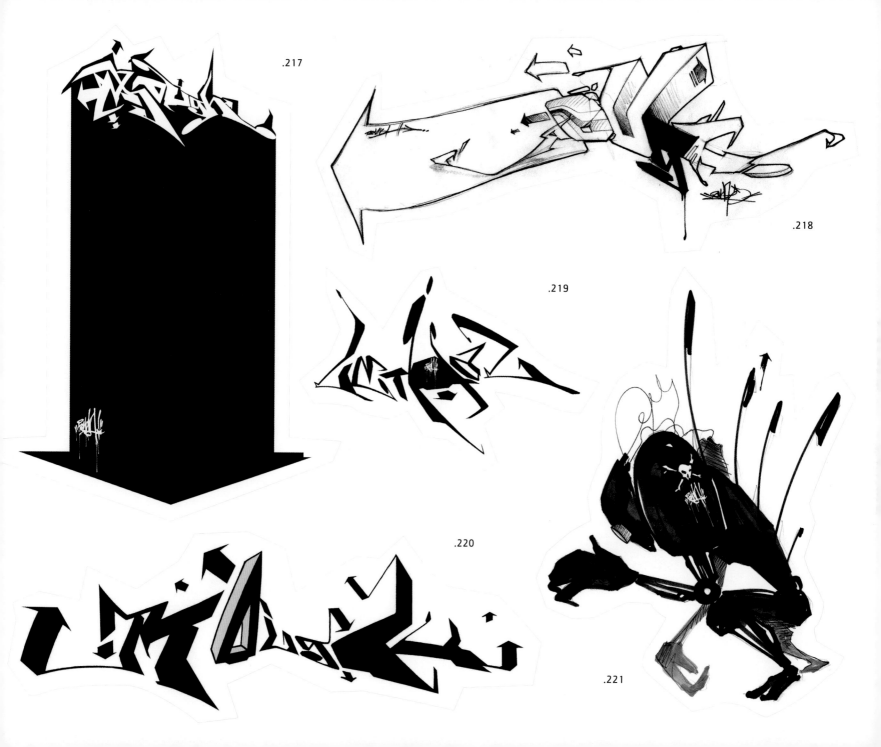

.217

.218

.219

.220

.221

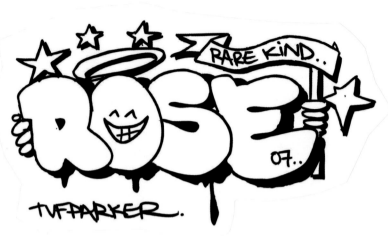

.222

.223

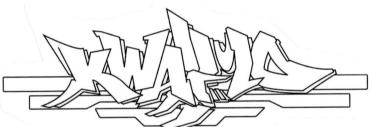

.224

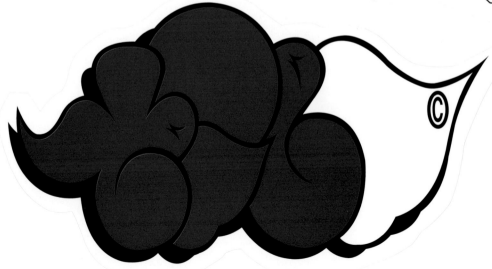

.225

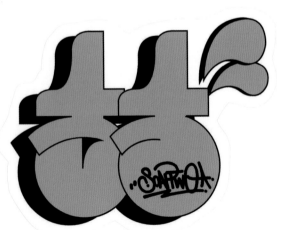

.226

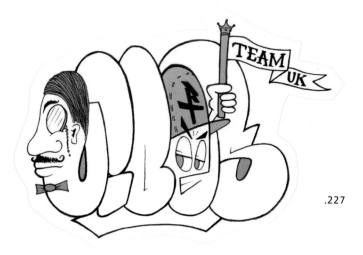

.227

.228

.229

.230

.231

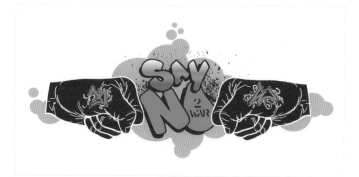

.232

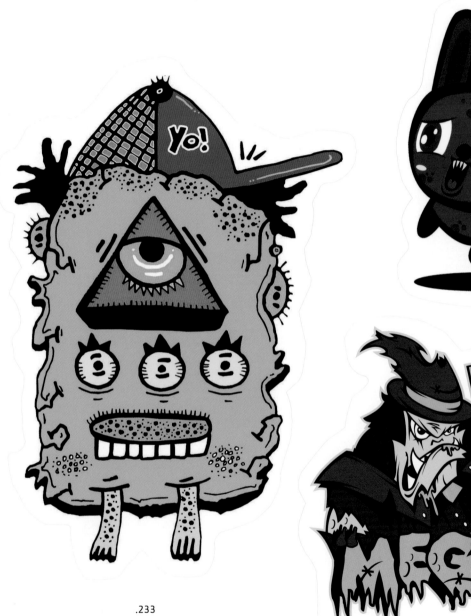

.233

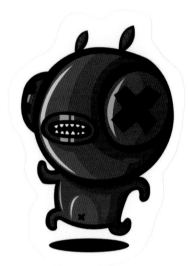

.234

.235

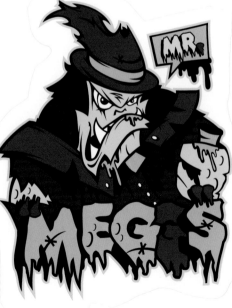

.236

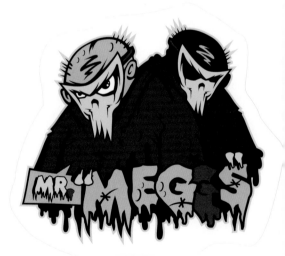

.237

.238

.239

.240

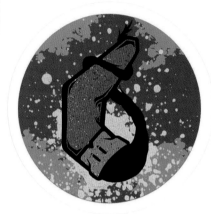

.241

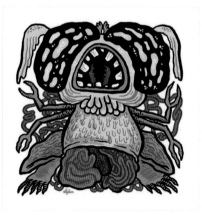

.242

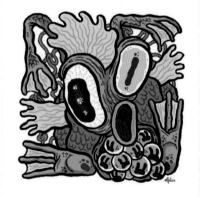

.243

.244

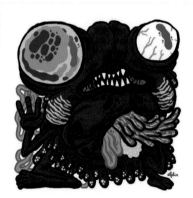

.245

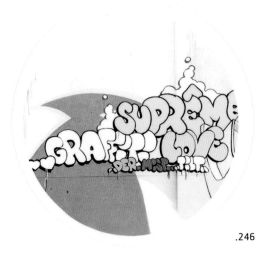

.246

.247

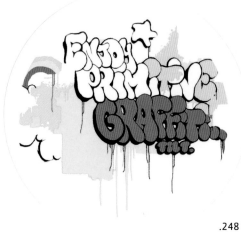

.248

.249

.250

.251

.252

.253

.254

.255

.256

.257

.258

.259

.260

.261

.262

.263

.264

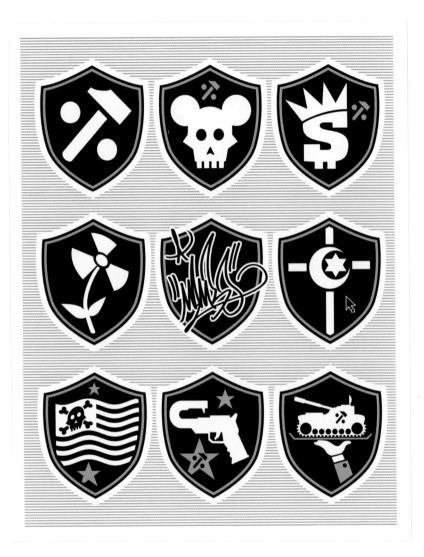

.265

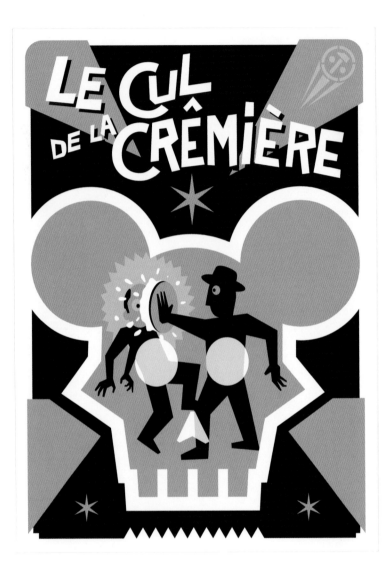

.266

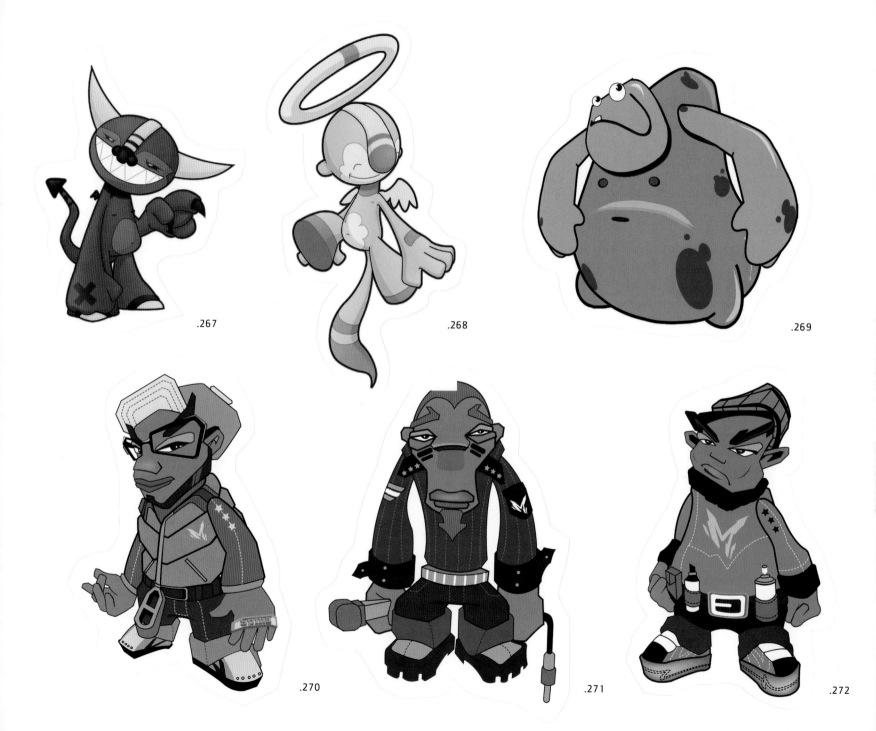

.267

.268

.269

.270

.271

.272

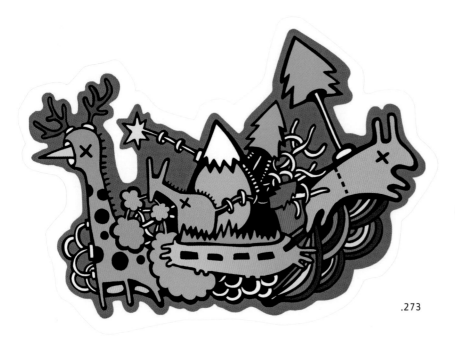

.273

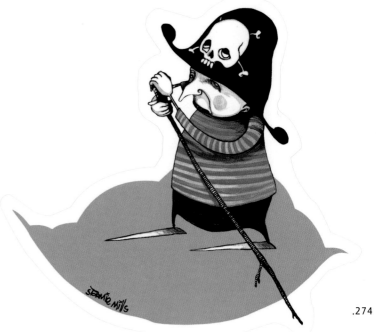

.274

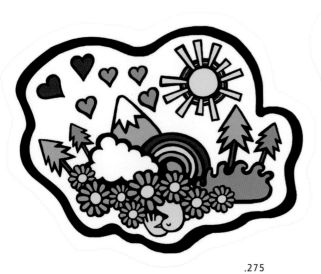

.275

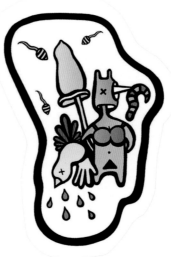

.276

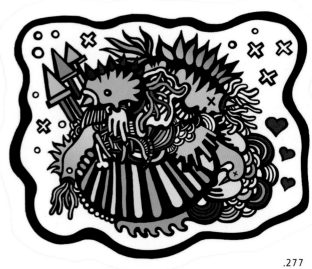

.277

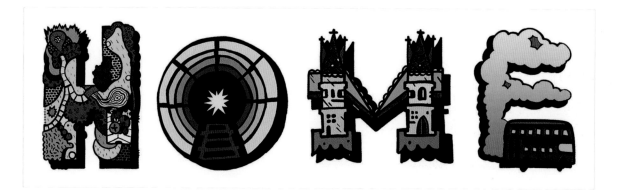

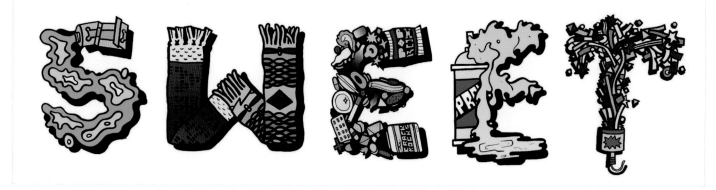

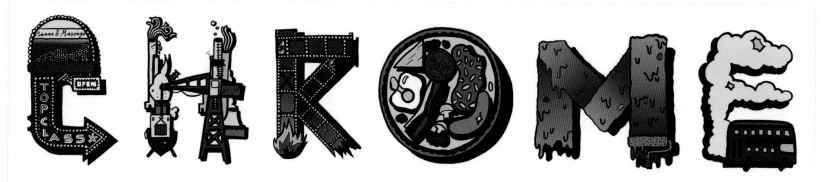

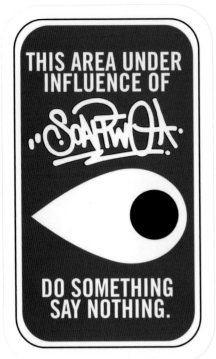

THIS AREA UNDER
INFLUENCE OF

DO SOMETHING
SAY NOTHING.

.279

STAY ALERT!

SOAPTWO

.280

SOAP

.282

2020 NEVER HAPPENED

.283

.281

Soapreme
Soapreme
Soapreme

.284

SOAP2

.285

.286

.287

.288

.289

.290

.291

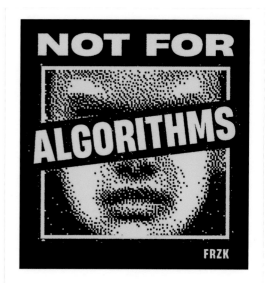

.292

.293

.294

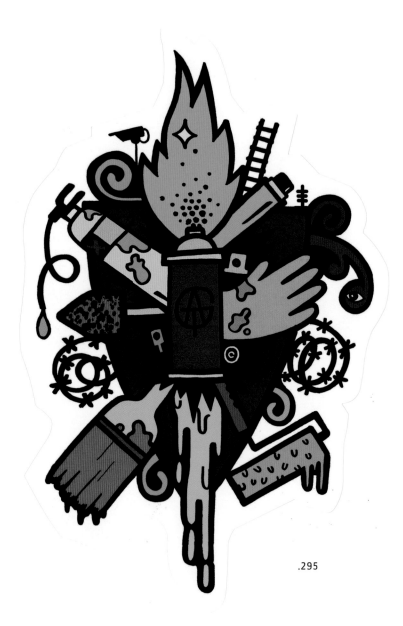

.295

.296

.297

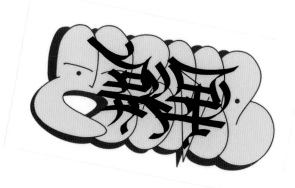

.298

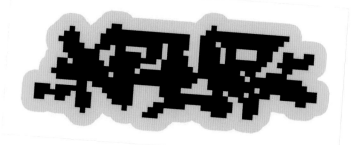

.299

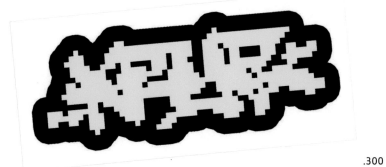

.300

.301

.302

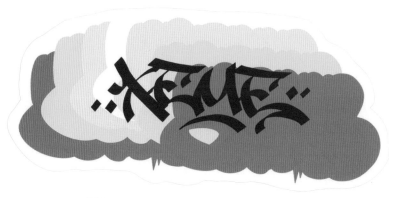

.303

I began making stickers when I started postering in Vancouver, Canada. It was a way of putting my art up on the streets while I was doing other things. I could put up a sticker while shopping, running errands, walking with friends. It made the mundane act of moving around city streets into something fun, like a game. I'd challenge myself to put them up in interesting places, somewhere obvious, while standing in the line to pay for groceries, or on a bus by the exit. Strangely, people would rarely (if ever) say something during the act. Of course, that didn't mean it went unnoticed. I'd hear later how someone saw my cute creations in a mail box, bringing them an unsuspecting smile, or my sticker made someone feel a little safer while walking a dark alley at night. These compliments helped me see that what I did had some meaning that went beyond just putting a label on a wall; it made some little tiny difference in people's lives. Of course, there were also drawbacks. Often, I'd see a lot of creations ripped, tagged over, cleaned up and in some way or another destroyed. In fact, few would survive for more than the 24-hour mark, and none would survive more than two years due to hostile weather. Yes, it's a fragile world when it comes to street art, but to bring one smile to one person is worth the thousands of times my hand slapped that sticky paper on some unsuspecting surface. Now I'm in Europe and it's time to share my art with new people and new places. The sticker game continues.

Basco5, Copenhagen, Denmark

The last time I ate stickers …

… I ripped the three remaining stickers into tiny pieces and popped them into my mouth. The sticker bit was actually easy to swallow, but the laminated paper wouldn't get softer no matter how much I chewed on it. Why did I have to eat the stickers? Because I was in a situation where I had to make them disappear like magic. I didn't eat them because I wanted to …

(From when he was locked up for tagging.)

Volt, Hiroshima, Japan

Onio is a pioneer of street art in the capital of Brazil, Brasilia. A lot of skateboarding influences in the 90s took him to the next level of self-expression, starting with tags, then paste-ups and throwies.

After ten years, Onio has developed an original style of drawings and letters, and represents it in all kinds of media: first the streets, then canvas, computer, hand-drawn paste-ups and silk-screen stickers.

Today he is a recognized artist in his country. Cities like São Paulo, Rio de Janeiro, Belo Horizonte and Goiânia have been the locations for his art shows and graffiti.

Onio, Brazil

Sticker index

.157 - Iloobia
.158 - Iloobia
.159 - Antiheroe
.160 - Antiheroe
.161 - Ores
.162 - Ores
.163 - Ores
.164 - Flavien 'Mambo' Demarigny
.165 - Flavien 'Mambo' Demarigny
.166 - Flavien 'Mambo' Demarigny
.167 - Koa
.168 - Koa
.169 - Koa
.170 - Koa
.171 - Koa
.172 - Mr Kone
.173 - Mr Kone
.174 - Mr Kone
.175 - Mr Kone
.176 - Mr Kone
.177 - Mr Kone
.178 - Kelp
.179 - Kelp
.180 - Kelp
.181 - Kelp
.182 - Kelp
.183 - Remi/Rough
.184 - Dibo
.185 - Dibo
.186 - Dibo
.187 - Matt Sewell
.188 - Papper och Penna
.189 - Papper och Penna
.190 - Papper och Penna
.191 - Mr Inside-Outski
.192 - mnwrks / Via Grafik
.193 - mnwrks / Via Grafik
.194 - mnwrks / Via Grafik
.195 - Matt Sewell

.196 - Tania Brun
.197 - Tania Brun
.198 - Tania Brun
.199 - Tania Brun
.200 - Tania Brun
.201 - Tania Brun
.202 - Imaone
.203 - Imaone
.204 - Imaone
.205 - Volt
.206 - Volt
.207 - Imaone
.208 - Rarekind
.209 - Rarekind
.210 - Spyre
.211 - Bspek
.212 - Bspek
.213 - Inkfetish
.214 - Spyre
.215 - System/Jason
.216 - System/Jason
.217 - Remi/Rough
.218 - Remi/Rough
.219 - Remi/Rough
.220 - Remi/Rough
.221 - Remi/Rough
.222 - Mr Roser
.223 - Panik
.224 - Cspeo
.225 - Tilt
.226 - Soap Two
.227 - Vibes
.228 - James Marshall (Dalek)
.229 - Kress
.230 - Papper och Penna
.231 - Jaes One
.232 - Knows
.233 - Onio
.234 - Orkibal

.235 - Orkibal
.236 - Meggs
.237 - Meggs
.238 - Lints
.239 - Lints
.240 - Lints
.241 - Lints
.242 - Elfelix
.243 - Elfelix
.244 - Elfelix
.245 - Elfelix
.246 - Tilt
.247 - Tilt
.248 - Tilt
.249 - Jon Burgerman
.250 - Jon Burgerman
.251 - Jon Burgerman
.252 - Jon Burgerman
.253 - Jon Burgerman
.254 - Kev Grey
.255 - Kev Grey
.256 - Kev Grey
.257 - Kev Grey
.258 - Kev Grey
.259 - Rath
.260 - Mundano
.261 - The Killer Gerbil
.262 - Mister Shrew
.263 - Mister Shrew
.264 - Mister Shrew
.265 - Flavien 'Mambo' Demarigny
.266 - Flavien 'Mambo' Demarigny
.267 - Okkle
.268 - Okkle
.269 - Nose Goodwin
.270 - Marka27 Quinonez
.271 - Marka27 Quinonez
.272 - Marka27 Quinonez
.273 - Eryburns

.274 - Stormie Mills
.275 - Eryburns
.276 - Eryburns
.277 - Eryburns
.278 - Jamie Jongo
.279 - Soap Two
.280 - Soap Two
.281 - Soap Two
.282 - Soap Two
.283 - Soap Two
.284 - Soap Two
.285 - Soap Two
.286 - Soap Two
.287 - Tim Hill
.288 - Papper och Penna
.289 - The Killer Gerbil
.290 - Mundano
.291 - Chã
.292 - Ferizuku
.293 - Asure
.294 - Asure
.295 - Mr Getup
.296 - Xeme
.297 - Xeme
.298 - Xeme
.299 - Xeme
.300 - Xeme
.301 - Xeme
.302 - Xeme
.303 - Xeme

Artist index

Orkibal / Malaysia
@orkibal
.018, .024, .025, .064, .113, .114, .115, .116, .117, .234, .235

Orko / UK
@jamesleeduffy
.091, .092, .093, .094, .095

Ortus / Serbia
@ortus369
.084, .085

Otek / Poland
www.flickr.com/photos/otecki
.026, .027, 0.28

Panik / UK
www.janatg.com
.223

Papper och Penna / Sweden
.041, .188, .189, .190, .230, .288

Phallic Mammary / USA
.044

Psilo Kid
@psilo.tattoos
.118, .119, .120, .121, .122, .123

Rarekind / UK
www.rarekind.co.uk
.208, .209

Rath / USA
.259

Remi/Rough / UK
www.remirough.com
.183, .217, .218, .219, .220, .221

Ren / Germany
.047

Sadmascot / South Africa
.015, .019, .020

Sasha Muravei / Russia
www.flickr.com/photos/sunytail
.142

Sat One / Germany
www.satone.de
.129, .130

Setdebelleza
@setdebelleza
.133, .134

Shohei Takasaki / Japan
www.shoheitakasaki.net
.128

Soap Two
@soaptwo
.226, .279, .280, .281, .282, .283, .284. .285, .286

Spyre / France
www.myspace.com/spyreone
.145, .210, .214

St Markus / Brazil
@saintmarkus
.087

Stephan Doitschinoff aka Calma / Brazil
@stephan_doitschinoff
.99, .100, .101, .102

Stormie Mills / Australia
www.stormiemills.com
.274

System/Jason / UK
www.400ml.com
.215, .216

Tania Brun / Peru - Switzerland
@tania_brun
137, .196, .197, .198. .199, .200, .201

Tenga / Japan
@tengaone
.105, .106, .132

The Artful Dodger / UK
@artful_dodger_01
.110

The Killer Gerbil / Singapore
@thekillergerbil
.141, .261, .289

Tilt / France
www.graffitilt.com
.225, .246, .247, .248

Tim Hill / UK
.287

Vibes / UK
@vibes_ldn
.227

Volt / Japan
.205, .206

Washio Tomoyuki / Japan
@washiotomoyuki
.103, .104, .107, .135, .136

Xeme
@xememex
.296, .297, .298, .299, .300, .301, .302, .303

Studio Rarekwai (2008) thanked all these people, including:
Laurence King, Jo Lightfoot, Iloobia, Jimi Crayon, Superflie, Rough1, Jamie Collinson, Tom Simpson, Das, Rose, Vibes, ATG, Kress, Volt, Askew, Dalek, Basco5, Cspeo.

Now in 2024, we are Soi Books and we'd like to say:
Thank you to Elen Jones for wanting to bring the *Stickerbomb* series back to life.
Thank you to Laura Paton, Felicity Awdry and September Withers. Big thanks to Steve Aston for joining the team and, with much sadness, RIP Orkibal and RIP Bytedust – two wonderful artists who aren't with us anymore.

And a big thank you to Laurence King.

Soi Books 2024

@bombstagram / @soico.xyz
www.stickerbombworld.com / www.soibooks.com